# Painting with O

4-29-22

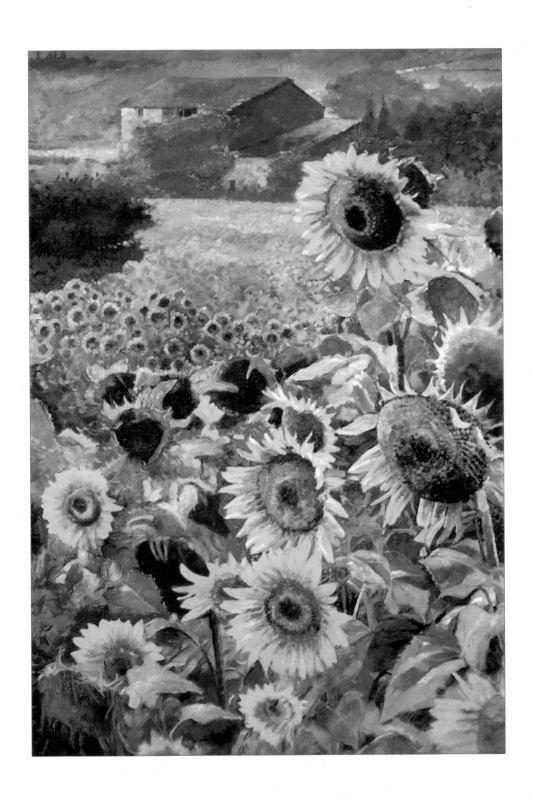

4-29-22

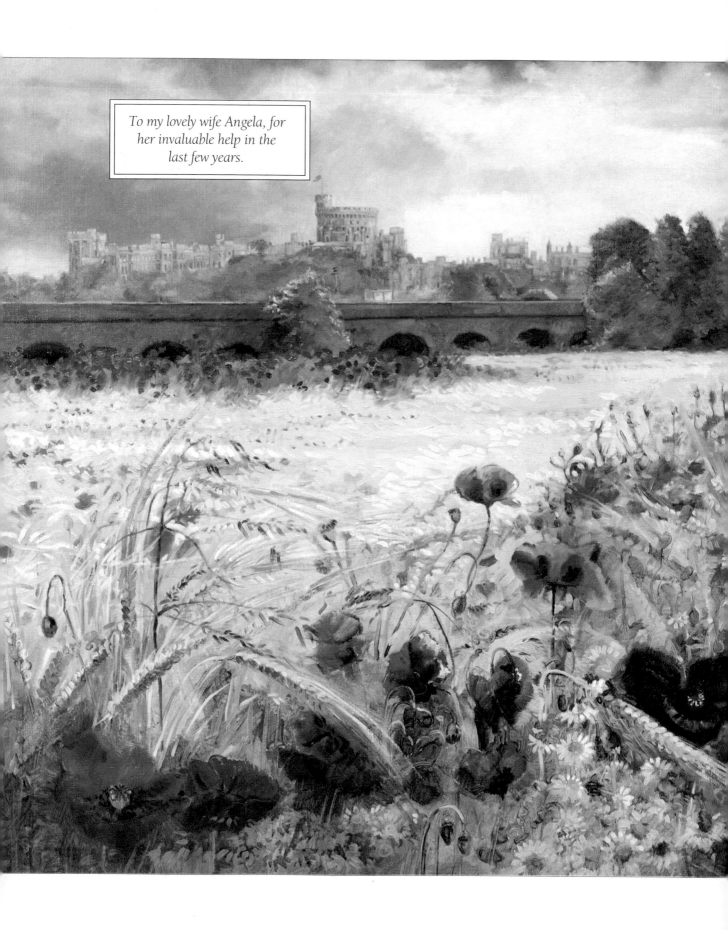

To my lovely wife Angela, for
her invaluable help in the
last few years.

# Painting
# with Oils

## NOEL GREGORY

SEARCH PRESS

First published in Great Britain 2000

Search Press Limited
Wellwood, North Farm Road, Tunbridge Wells, Kent TN2 3DR

Reprinted 2000, 2001, 2002

Text copyright © Noel Gregory 2000

Photographs by Search Press Studios
Photographs and design copyright © Search Press Ltd. 2000

ISBN: 0 85532 900 9

The publishers and author can accept no responsibility for any consequences arising from the information, advice or instructions given in this publication.

The publishers would like to thank Winsor & Newton for supplying many of the materials used in this book.

Suppliers
If you have difficulty in obtaining any of the materials and equipment mentioned in this book, then please write to the Publishers at the address above, for a current list of stockists, including firms who operate a mail-order service. Alternatively, write to Winsor & Newton requesting a list of distributers.

Winsor & Newton, UK Marketing
Whitefriars Avenue, Harrow, Middlesex HA3 5RH

Publisher's note

All the step-by-step photographs in this book feature the author, Noel Gregory, demonstrating how to paint with oils. No models have been used.

There is reference to sable hair and other animal hair brushes in this book. It is the publisher's custom to recommend synthetic materials as substitutes for animal products wherever possible. There are now a large number of brushes available made from artificial fibres and they are satisfactory substitutes for those made from natural fibres.

Colour separation by Graphics '91 Pte Ltd, Singapore
Printed in Spain by Elkar S. Coop. 48180 Loiu (Bizkaia)

*I would like to thank the staff of High Wycombe College of Art, who started my artistic career in the 1960s. Their encouragement and insistence on teaching me how to draw, helped me achieve what I so enjoy today.*

*I am indebted to the huge talent of the Victorian and Edwardian artists, whose work made me realise that there is so much to learn, and to Claude Monet in particular, whose paintings, even after one hundred years, seem so relevant and modern.*

*I would also like to express my sincere gratitude to Melissa Mee, who started me painting again after a long period of just dealing in pictures.*

*Noel Gregory*

*Page 1*
*Sunflowers, Provence, France*
*810 x 1220mm (32 x 48in)*
*The visual impact of acres of these sunflowers in bloom is breathtaking. For me they are the most exciting of all flowers, especially when they are painted full size on a large canvas.*

*Page 2*
*Windsor Poppies*
*1220 x 915mm (48 x 36in)*
*This riot of colour sprang to life after the soil was disturbed during ploughing. I made reference sketches on location, then completed the painting in the studio.*

# Contents

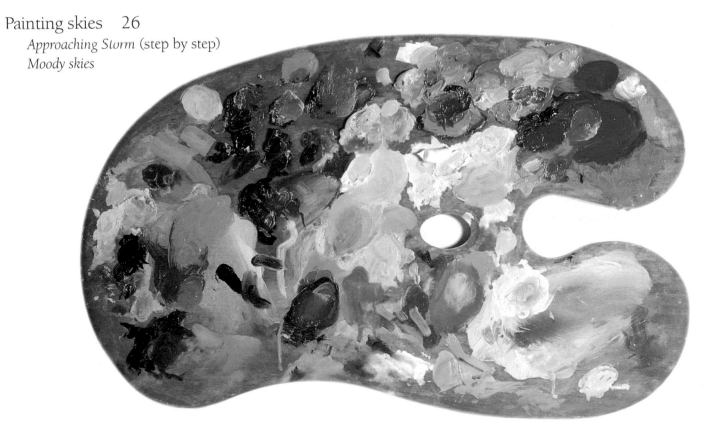

# Introduction

To my mind, oil paint is the most versatile of all painting mediums. You can develop the painting as you work, moving colours about on the canvas to refine shape, tone and texture, and you do not have to worry about your drawing skills as you can paint over mistakes. There will be days when you may feel like painting thick, heavily-textured images, and others when you want to create a soft, smooth effect using thin colours. You may want to paint in great detail or perhaps just work up a sketch on the spot. However you want to paint, it is a wonderful medium to work with.

Many people think of watercolours as the perfect medium for beginners, and this may have something to do with their first experience of poster colour and powder paint at school. However, anyone starting to paint will soon discover that oils are so much easier to use.

Many beginners find a blank canvas intimidating. An artist friend of mine was demonstrating his superb talent for drawing birds from memory at an exhibition and was surrounded by interested observers. One couple watched him in silence for many minutes. Suddenly, the woman smiled and said to her partner, 'I can do that'. It had taken the artist most of his life to master his technique, and he was about to comment when she went on to say, 'but I do not know where to put the lines'. This is a common response from people who would like to paint, but lack the confidence to start. However, if you work with oils, starting with a blank canvas is easier. You only have to concern yourself with basic outlines, before you can start creating your first masterpiece.

This book takes you through all the basic principles of painting with oils. The step-by-step sequences are designed to help build up confidence and develop skills. The finished paintings will inspire you to create your own pictures. As you gain more confidence, you will gradually develop your own style of painting and soon afterwards you will be able to say, 'I now know where to put the lines'.

*Opposite*
**Lazy River**
*405 x 510mm (16 x 20in)*

*Subjects can often be found in the most unexpected places. Simple everyday scenes can be perfect – you do not have to travel far to find inspiration. This tranquil scene is actually near a built-up industrial area and close to a very busy road. Even if it had included an ugly building, I could have omitted it and replaced it with, say, a nearby tree. You can easily leave something out of a composition if you feel like it.*

*I love painting scenes like this – a day out, sketching on the spot, with just a small canvas, some paints and a picnic. What a wonderful way to make a living; I am very fortunate.*

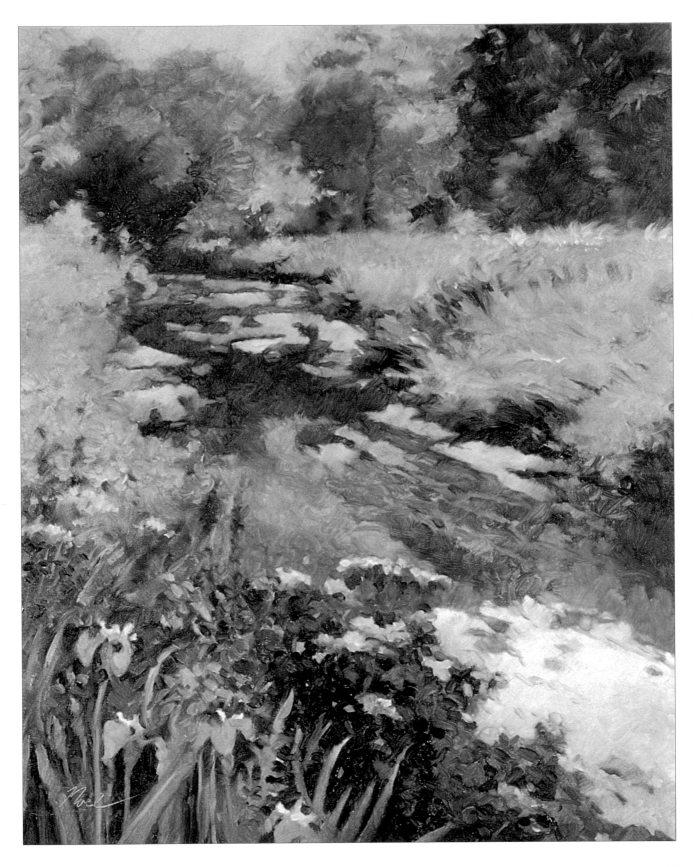

# Materials

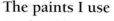

Even as a professional artist, I feel intimidated by the many different brushes that are available – and by the seemingly endless number of colours and different surfaces that are on offer. However, you must not be put off by this vast array. You can start painting with just two or three brushes and a few colours, then add to your collection as you become more experienced.

## Paints

Oil paints are colour pigments mixed with a binder (usually linseed, poppy or safflower oil) and they are available in different qualities. Artists' quality paints are the best – they are the most expensive, but they contain the highest grade and greatest quantity of pigments. Students' quality colours are also very good, and are more than adequate for anyone starting to paint.

Buying too many colours at first may lead to confusion. It is better to start painting with just a few colours and then add more later. Alternatively, you might consider buying one of the excellent boxed sets that are available.

Over the years I think I have tried every colour available, but experience has led me to refine my palette of colours to the eighteen shown here.

### Whites

There are a number of different whites available, each having different properties. The three most commonly used are flake white, titanium white and zinc white.

**Flake white** is the silver white which was used by the Old Masters. It is quick drying, a quality which makes it excellent for glazes. It is also more flexible and durable than other whites. However, care must be taken when using it as it contains a poisonous substance.

**Titanium white** is generally regarded as the modern replacement for flake white and, nowadays, it is probably the most widely used. It is the whitest and most opaque of all, but because of its strength, it may overpower transparent colours.

**Zinc white** is less opaque than titanium white making it excellent for glazes and tints. However, it dries quite slowly.

---

**The paints I use**
Cerulean blue
Cobalt blue
French ultramarine
Phthalo blue
Cobalt violet
Permanent mauve
Cadmium red
Alizarin crimson
Chrome yellow hue
Indian yellow
Cadmium yellow
Yellow ochre
Permanent green light
Viridian hue
Burnt sienna
Vandyke brown
Ivory black
Titanium white

## Palettes

Virtually anything that provides a flat mixing surface can be used as a palette – a piece of glass or plastic, a sheet of grease-proof paper, or even plastic food wrap stretched over a board. You will be holding your palette for considerable lengths of time, so do not choose one that is too big or heavy.

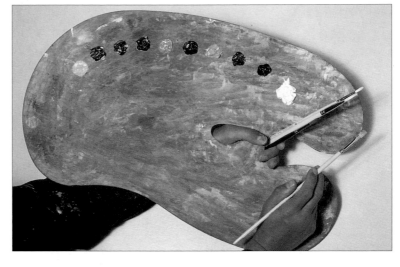

I like to hold my colours near the painting, and I have found that a wooden palette suits me best. Here I have laid out the colours from a boxed set (from left to right): cadmium yellow, alizarin crimson, French ultramarine, phthalo blue, permanent green light, viridian hue, yellow ochre, burnt sienna, ivory black and titanium white. I always lay my colours in the same position around the edge, so I know exactly where each one is. I use the rest of the space to build up mixes as I paint.

I love my palette – it becomes part of the picture, reflecting the mood of the subject as colours are added and blended.

## Mediums

There is a vast array of mediums and additives available and their uses only become apparent with experience. However, the essentials are linseed oil and turpentine (or white spirit). Linseed oil is used to thin the paints and to help them flow. Turpentine is also used as a mixing and thinning aid, and for cleaning up after a painting session. I usually use linseed oil for mixing paints because it delays drying times. You can buy small metal 'dippers' to hold these mediums – they are designed to clip on to a palette.

## Brushes

Brushes are made from natural hair or bristle, synthetic fibre, or a mixture of both. Generally, natural hair (sable) brushes are best for watercolours, natural bristle (hog) brushes for oils, and synthetic brushes for acrylics.

I use small- and medium-sized short, flat hog-hair brushes (brights) for general painting, and small, round sable-hair brushes for fine detail. However, you should try out other shapes of brushes and select those you find easiest to work with. Explore the different properties slowly, and do not buy too many at first.

## Surfaces

The best inexpensive painting surfaces are ready-primed canvas boards. Ready-primed paper, which you can mount yourself, is also available as loose sheets or in pad form.

Personally, I prefer to paint on traditional canvas as it has two distinct advantages over other types of painting surface: it can be assembled on stretcher pieces to virtually any size without being too heavy; and it also provides 'give' for brush movement, which is lacking with a rigid surface. I use a fine-grained linen canvas, although good-quality cotton canvasses are perfectly acceptable.

Smooth MDF is used by many artists seeking to attain photo-realism, because of its lack of texture, but it still needs to be primed and then sanded to a silken finish to achieve the desired effect.

## Easels

You cannot readily paint with a canvas on your lap – a canvas needs to be upright, so you will need an easel. Again, there are many different types available. Some have a box for paints and brushes with space for a completed canvas in the lid. However, adjustable, wooden sketching easels are perfectly adequate; they are generally lightweight, easy to erect and they can support surprisingly large canvasses. Folding artists' donkeys, bench- and table-top easels are also worth considering.

# Colour mixing

Experimenting with colour mixing will help you understand the nature of colours, and how they react with each other. It is quite possible to paint a picture using mixes of just three primary colours (red, yellow, blue) and white. The finished colour wheel below shows the enormous range of colours and tones that can be created using only alizarin crimson, cadmium yellow, French ultramarine and titanium white.

> **Note** *Try painting a colour wheel using another red, blue or yellow and see the differences in colour and tone that can be achieved.*

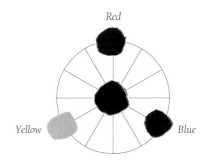

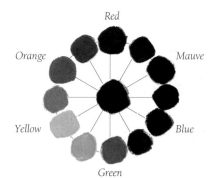

1. Paint circles of red, yellow and blue at the points shown. Then mix equal amounts of each together to create a neutral grey and paint this in the centre.

2. Next, mix a mauve from equal parts of red and blue, an orange from red and yellow, and a green from yellow and blue. Paint these secondary colours between the respective primary colours.

3. Now mix equal parts of each primary colour with each secondary colour and paint these intermediate colours in the appropriate gaps in the circle.

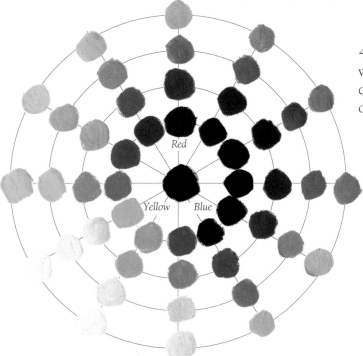

4. Finally, progressively add touches of white to each of the twelve colours to create lighter tones, and radiate these out from the original colours.

# Understanding tone

Painting is about confidence and this can be developed in many ways. One way is to study tone, or degrees of light and dark. A look at Rembrandt's work shows us how important tone is. It has been said that if you can master this fundamental technique there is little left to learn, and I thoroughly agree with this sentiment. I would go further and say that you could, perhaps, get away with poor drawing and colour, but if you do not understand the tonal structure of a painting, you will always create weak images.

One way to appreciate tone is to look at a subject through half-closed eyes. Restricting your vision in this way eliminates all detail except for the bright highlights and dark shadows.

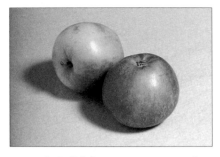

*A simple, still-life composition is perfect for practising the techniques of tonal structure. Light it from one side to create a strong tonal contrast.*

## Apples

Still-life subjects like this simple composition, provide a very good opportunity for experimenting with tonal values. Apples have an interesting form, and lighting them from one side creates good highlights and strong shadows. Their shape and form are created with intermediate tones.

This demonstration is painted on a 255 x 205mm (10 x 8in) canvas, using titanium white and ivory black (mixed with a touch of burnt sienna). The burnt sienna softens the black, which is too harsh when used on its own.

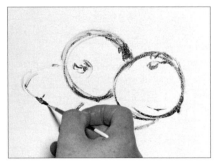

1. Dilute ivory black with linseed oil, then add a touch of burnt sienna. Use a small, round sable brush to loosely sketch in the outlines of the two apples and their shadows.

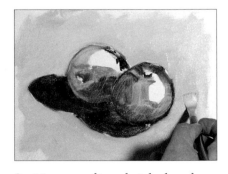

2. Use a medium bright brush and various strengths of the black mix to wash in the large areas of intermediate tones, and the dark shadows. Paint the background using titanium white with touches of the black mix.

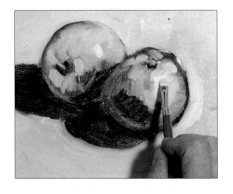

3. Now add highlights and start to develop the 'tonal shape' of the apples. Use a small bright brush to build up the paint, making curved and straight strokes that follow the contours of the apples.

4.  Use a dry medium bright brush to blend the paint and soften the edges of the images. If you leave the painting to dry slightly – say overnight – you will find it easier to blend the colours.

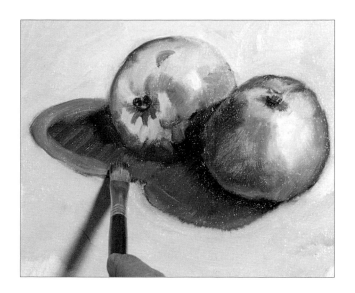

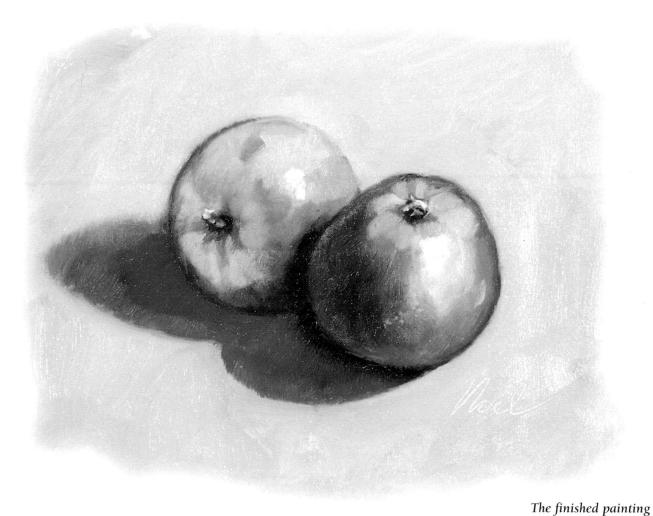

*The finished painting*
*Fine details have been added and the paint layers strengthened slightly. Final touches of pure titanium white have been used to create the brightest highlights.*

# Using a limited palette

You can continue to build up your confidence by adding a few more colours (from the same part of the colour spectrum) to your palette. Painting with a limited palette will help you concentrate on creating good three-dimensional images without having to worry about 'seeing' and mixing too many colours. Obviously it is easier if you choose a subject with a limited colour range, as I have here.

## Mushrooms

These mushrooms are comprised of tones of brown at the warm end of the spectrum, so I have added just two primary colours (cadmium red and chrome yellow hue) and Vandyke brown, to the black, white and burnt sienna used for the tonal study on pages 12–13. The picture is painted on a 255 x 205mm (10 x 8in) canvas.

*Side lighting this simple composition produces good tonal qualities.*

Look at the shapes of the mushrooms as simple blocks of colour. Start with the largest blocks, then gradually paint progressively smaller blocks, leaving the fine details until the last possible moment. Try to think of details as just tiny blocks of colour that sit on the surface of larger ones. With these mushrooms, for example, it is not necessary to paint in every individual gill, you just need to create shapes that indicate the form of their mass.

1. Mix a wash of linseed oil and burnt sienna, then quickly draw the outlines of the mushrooms, using a small round sable and firm strokes to capture their shapes.

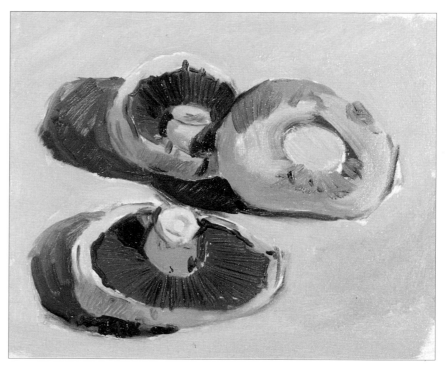

2. Use a medium bright brush and a mix of red, yellow and white to block in the background. Mix the brown with a touch of white and black, then paint in the darker areas. Remember to constantly look at the subject through half-closed eyes to discover where the darkest areas lie, then look at the lightest areas and add these as simply as possible.

3. Now use a small bright brush to build up the tone, painting in the darker areas and developing the form and details of the mushrooms.

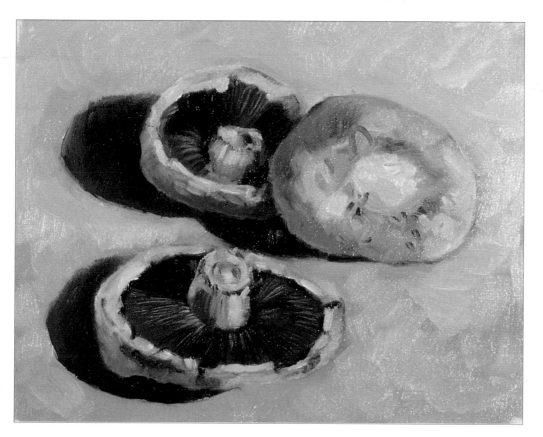

**The finished painting**
More details have been added using a small sable brush. The brightest highlights and the darkest darks are the last to be applied.

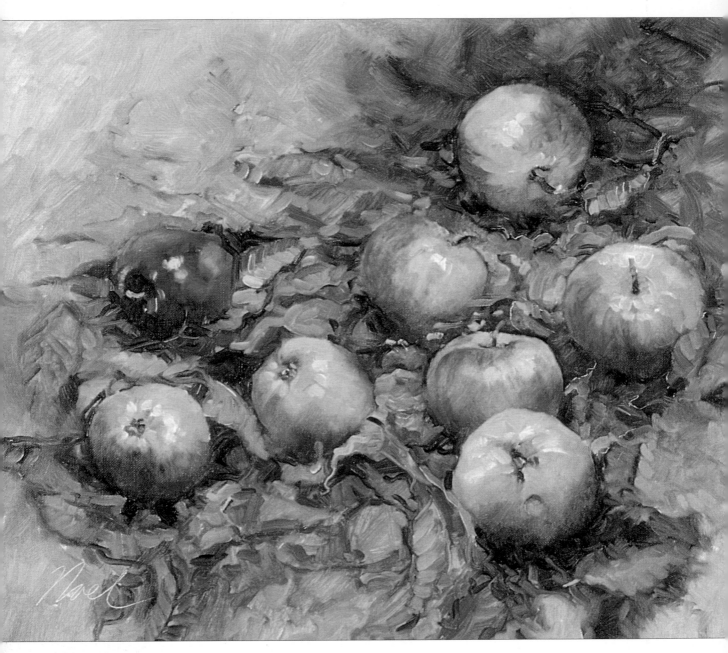

## Fallen Apples
*510 x 405mm (20 x 16in)*

*Apples and mushrooms were chosen as subjects on the previous pages because of their simple shapes. The same subjects can be developed into beautiful full-colour paintings. This picture of apples, and the mushroom painting opposite show how interesting compositions can be created from these simple subjects – they were both set up as still-life compositions in the studio with a strong light from one side.*

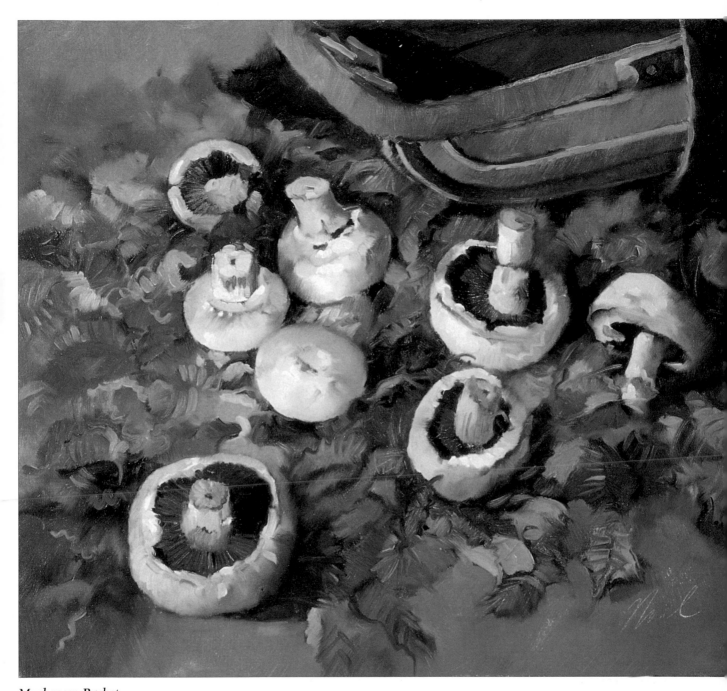

**Mushroom Basket**
*510 x 460mm (20 x 18in)*

*This painting was worked up in much the same way as the mushroom demonstration on pages 14–15, but this time I used my full palette of colours (see page 8).*

17

# Painting outdoors

Painting still-life images in the studio is fine, but for many, working outdoors is the ultimate challenge. The most difficult problem is getting the right perspective. How do you create a three-dimensional image in just two dimensions?

Perspective is as complex a subject as art itself – it has been refined and changed throughout history, but, in simple terms, it is just a formula for size and proportion. Objects of similar size appear smaller the further they are from the ground line, and parallel lines appear to vanish to points on the horizon.

One simple way of achieving the right scale and the correct angles is to sight-size major parts of the scene, using the handle of your brush and your thumb as a ruler to scale selected objects. Hold the brush at arms length, close one eye, align the tip of the brush at one end of an object, then move your thumb along the brush until it aligns with the other end of the object. Transfer this measurement on to your canvas. You can use the same technique to record the angles of the various elements of the scene.

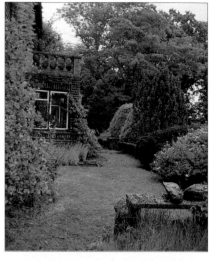

*This garden scene is an ideal subject to practise the sight-sizing method of creating an initial sketch.*

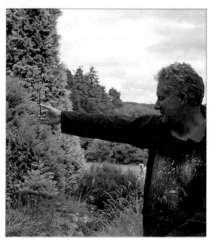

*When sight-sizing, stand close to your easel so that you can transfer scaled measurements without moving your position. Always hold your arm straight out in front of you, and always use the same eye to view the object being scaled.*

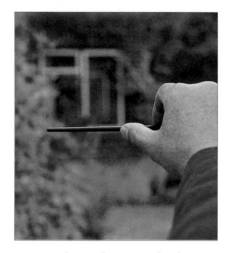

1. Start by scaling simple shapes such as this window. Hold the brush parallel to the bottom edge of the window with its tip aligned with the left-hand side. Then, without moving your arm, slide your thumb along the brush until it aligns with the right-hand side of the window.

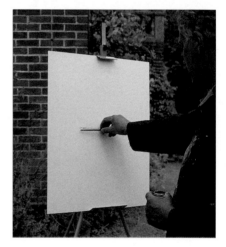

2. Without moving your feet, swing round to face the easel and transfer the scaled measurement to the canvas. You may find that the objects you are measuring are smaller than you first imagined.

3. Now hold the brush parallel to the side of the window. Align its tip with the top edge and use your thumb to scale the height of the window.

4. Swing round and transfer this measurement to the canvas. Continue sight-sizing the outlines of the building and transferring them to the sketch.

5. Use a similar technique to sight-size angles, for example, the angle of the low garden wall. Hold the brush square to the ground line, and angle it so that it aligns with the top of the wall.

6. Again, swing round and transfer this angle on to the sketch. Continue to sight-size the other major elements of the scene in a similar manner.

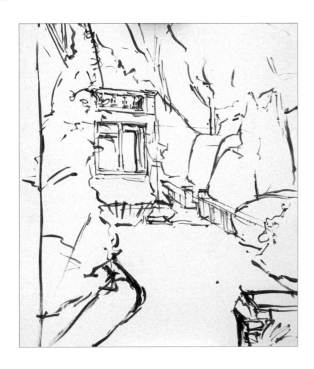

### The completed sketch

*Once the main elements and angles have been sketched in, it only takes a few minutes to link them all together. It is not necessary to produce a finely detailed sketch at this stage – indeed, if the drawing looks too good, you may be tempted not to spoil it by painting it.*

*I distinctly remember the first time that I used sight-sizing. I was a second-year art student and the subject was a road, a fence and a few houses. Sight-sizing showed me the scale of background objects relative to those in the foreground. It also helped me to understand how the sides of the road appeared to taper. Suddenly, the whole composition became three-dimensional, with a real impression of distance. This was something I had found hard to master before, and that day was one of the most exciting of my artistic career. I still have the painting at home.*

# Landscapes

Beginners often choose to paint landscapes. Wherever you live, whether it be in a town or in the countryside, we are surrounded by ever-changing seasons and subjects. Most landscapes can be quite a challenge, so it is better to find an easy subject to start with. A simple scene with a tree and a path is all you need to help develop your confidence in capturing perspective, colour and tone.

## Country Lane

At first glance, this landscape may seem quite complicated, but when you use the sight-sizing technique to compose the initial sketch (see pages 18–19) it becomes a simple arrangement of different elements. You just have to fill these elements with blocks of colour, then add the detail.

I painted this landscape on a 610 x 460mm (24 x 18in) canvas. I used small- and medium-sized short, flat hog-hair brights, a small round sable and the ten colours from the boxed set listed on page 9.

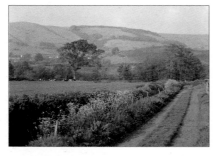

*It is always worthwhile taking a photograph, in case you have to finish your painting in the studio.*

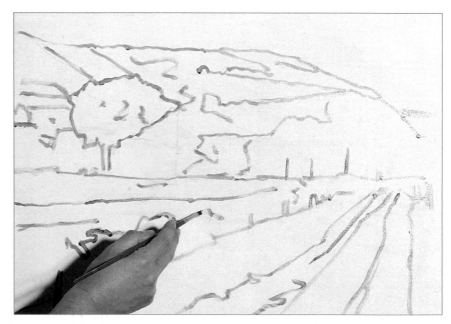

1. Mix a thin wash of Vandyke brown and linseed oil, then use a small round sable to draw the basic elements of the scene on to the canvas. The most important lines are those that create the perspective of the lane and the hedge. Sight-size these angles, transfer them on to the canvas, then mark in the horizon. Scale the middle distance trees, then gradually add the shapes of the distant fields. Try not to overdo the detail on this initial sketch – the paint will do the 'real' drawing as the picture develops.

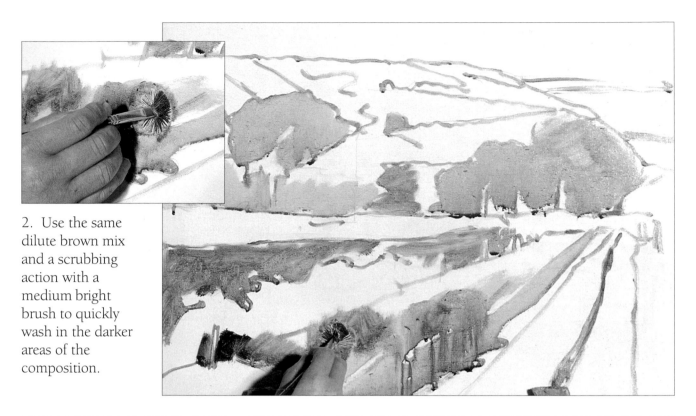

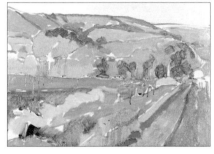

2. Use the same dilute brown mix and a scrubbing action with a medium bright brush to quickly wash in the darker areas of the composition.

3. Block in the foreground areas with a mix of permanent green light and titanium white. Add touches of cerulean blue to the green mix and block in the middle distance areas. Then, as the soil colours in this particular scene are so hot, add a touch of cadmium red to the mix, and paint in the distant hills.

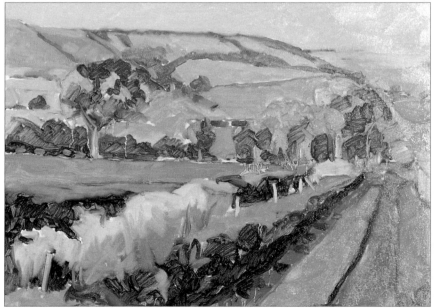

4. Continue blocking in the landscape and sky, gradually adding smaller shapes, until the whole canvas is covered with colour.

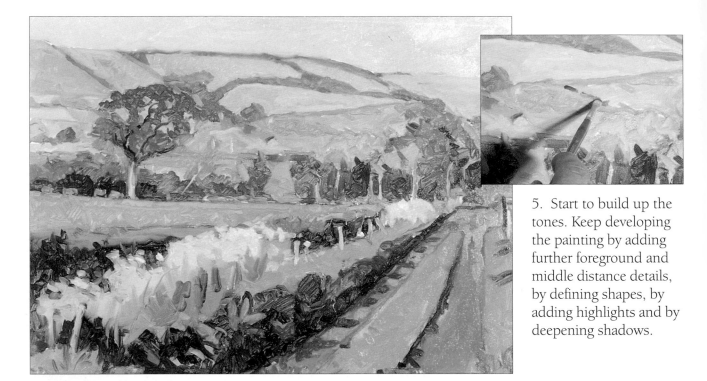

5. Start to build up the tones. Keep developing the painting by adding further foreground and middle distance details, by defining shapes, by adding highlights and by deepening shadows.

6. Use a clean, dry, medium bright brush to move the paint around and soften each area. Work over the whole painting, wiping the brush clean regularly to retain the freshness of the colours on the canvas.

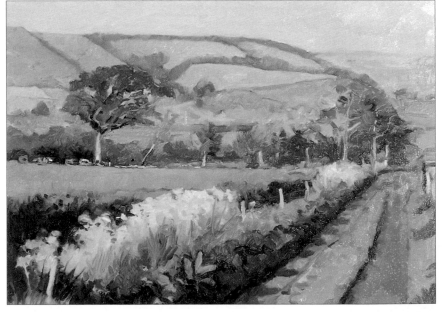

7. Continue developing the canvas, building up and moving the paint around on the surface, letting the brush strokes produce interesting textures. Do not worry about what brush to use, experimentation will provide the answer. Similarly, you do not have to mix every colour on the palette – you can change and mix colours on the canvas during painting. For example, if a green area is too blue, add some yellow on top, then move the paint about until you achieve the desired colour.

8. Develop specific parts of the painting by adding fine detail. A small round sable brush is useful when painting lines such as this wire fence. It also creates the smallest brush strokes making it ideal for painting foliage and tiny bright highlights.

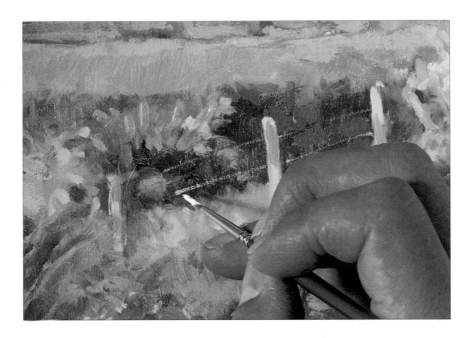

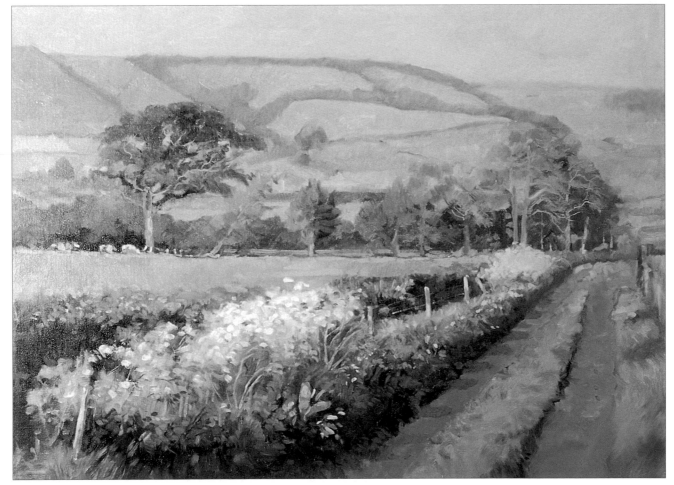

*The finished painting*

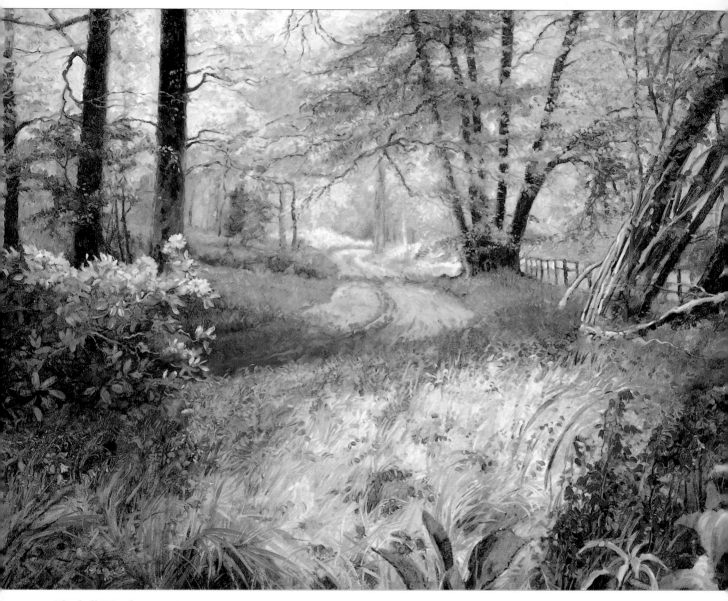

## Bluebell Wood
*1015 x 760mm (40 x 30in)*

*Both this painting and the one opposite are examples of interesting landscapes. I painted them on the spot, and worked for approximately one week on each painting. Both were started in exactly the same way as the landscape demonstration on pages 20–23. In the painting above, a strong feeling of perspective is created by a simple path leading the eye into the far distance. I took foliage back to the studio to complete the foreground.*

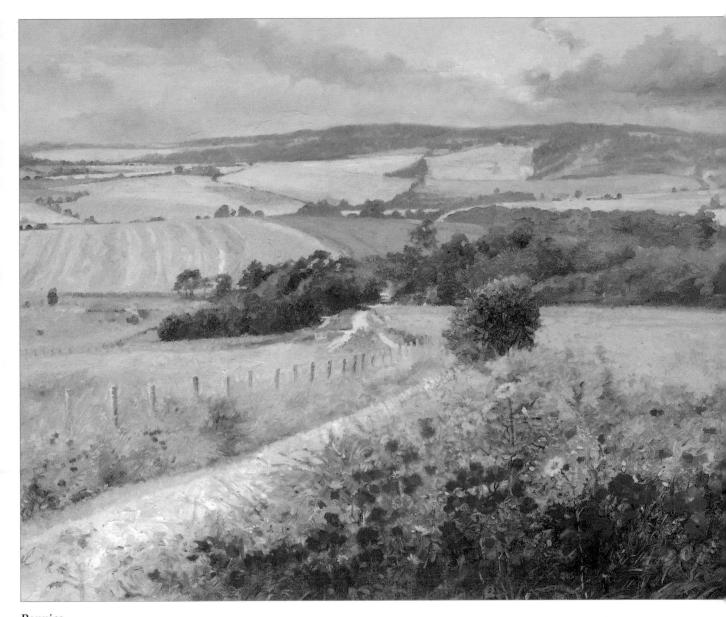

**Poppies**
*760 x 610mm (30 x 24in)*

*Sunlight has a great deal to do with the impact of this painting, and the heavy clouds give it a more dramatic effect than would a clear blue sky. The path leading down to the trees in the middle distance takes the viewer past the colourful summer fields. There is a wonderful feeling of space and perspective which is heightened by the red poppies in the foreground and the blue misty hills in the distance.*

# Painting skies

Skies create mood in a landscape, and I love painting them. They can add drama to a simple landscape, or act as a plain background for a more complicated scene. I often think of a Constable sky when I see dramatic cumulonimbus clouds, and few would not comment on seeing a glorious red sunset. Examples of how the sky can influence the mood in a landscape are shown on pages 28 and 29.

*Note* *Skies change by the minute, so use your camera to take as many reference photographs as possible. Magazines and books are also excellent reference sources, as are reproductions of Old Masters. Keep everything in a scrap book; in that way you will always be able to find a suitable image to transform an otherwise dull landscape.*

## Approaching Storm

This sky, painted on a glorious sunny day which was suddenly interrupted by rain, can be recreated using simple techniques. It was painted on a 255 x 205mm (10 x 8in) canvas, using small- and medium-sized short, flat hog-hair brights, a small round sable, and cobalt blue, French ultramarine, chrome yellow hue, alizarin crimson, Vandyke brown, ivory black and titanium white.

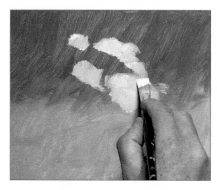

1. Use a medium-sized bright brush and a mix of cobalt blue and ultramarine diluted with linseed oil, to wash the colour over the canvas. Add touches of titanium white to the mix as you work towards the bottom of the painting. Then load the brush with titanium white and start painting in the clouds.

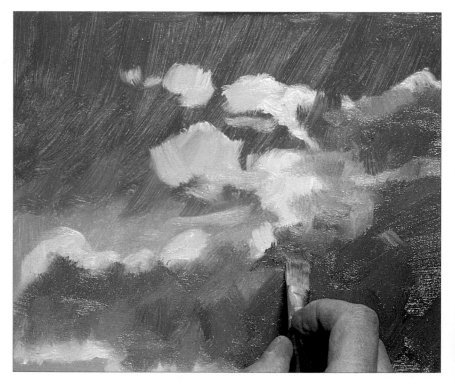

2. Lay in areas of dark clouds using various mixes of Vandyke brown, French ultramarine and touches of ivory black. Blend the colours, then use mixes of alizarin crimson and chrome yellow hue to highlight the top of the clouds.

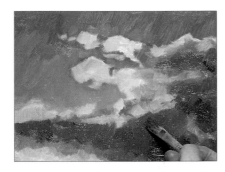

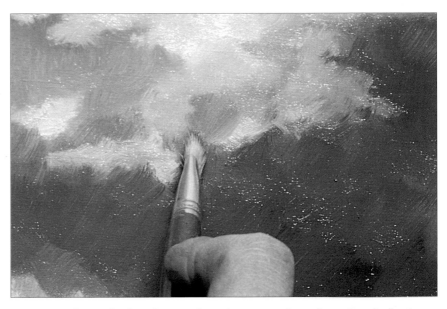

3. Now mix alizarin crimson and French ultramarine, and start to work the darker areas of clouds. Keep building up layers of paint, mixing and blending the colours on the surface of the canvas.

4. Use a clean, dry brush to soften the painted strokes. Gently feather and blend the colours until the paint is smooth and less textured.

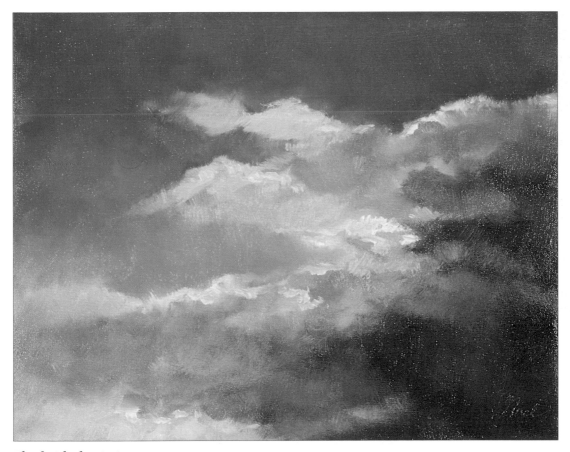

**The finished painting**
*Highlights of pure titanium white have been added with the sable brush as a final touch.*

# Moody skies

The paintings on these two pages show how the sky can dramatically influence the mood in a landscape. Although each picture is different, the sky is the predominant feature in all of them. Note how the colours used on the land areas are influenced by those in the sky.

They were all painted *in situ*, although the foreground poppies in *Summer Sky* opposite were painted from a still-life composition back in the studio.

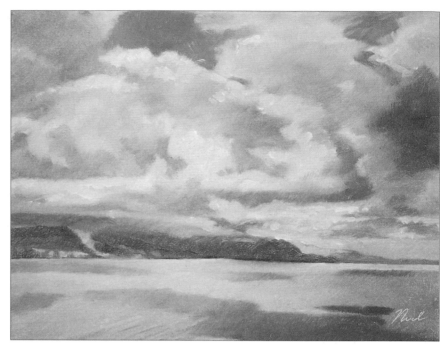

***Stormy Headland***
*255 x 205mm (10 x 8in)*

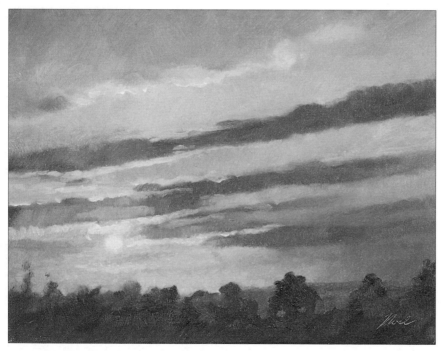

***Sunset and Clouds***
*255 x 205mm (10 x 8in)*

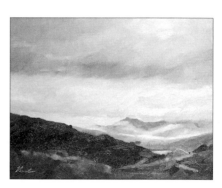

***Mountains and Clouds***
*255 x 205mm (10 x 8in)*

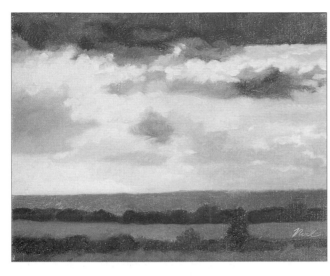

**Distant Hills and Sky**
*255 x 205mm (10 x 8in)*

**Summer Sky**
*610 x 405mm (24 x 16in)*
*Sometimes, a completely tonal, one-colour-only sky can be very beneficial to a finished painting. In this painting there is more than enough interest in the landscape, and the smoothness of the sky complements the different textures and the fine detail in the foreground.*

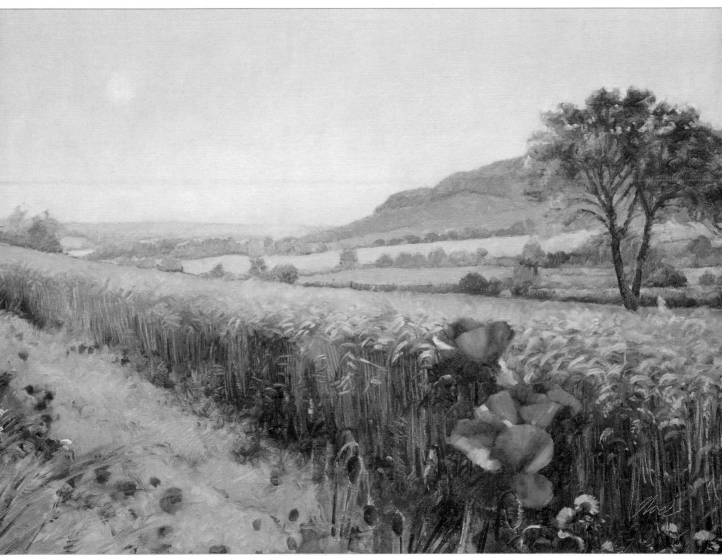

# Painting trees

For some reason many beginners find trees difficult to paint. This could be because they try to capture everything they 'see'. If you simplify the trunks, branches and leaves they are really quite easy. Trees never change their shape, regardless of the season. In winter they are a mass of twigs, while in summer they are a mass of leaves. Children draw trees as simple circular shapes with straight lines, then colour the tops green and the trunks brown. There is nothing wrong with this approach – you just need to do a bit more work to define the shape and form without drawing every leaf or twig.

> **Note** *Trees are just a series of small simple shapes that combine to make the whole. Never try to paint too much detail – you do not have to show every leaf or twig to make your tree look realistic.*

## Majestic Cedar

The techniques described here can be used to paint all trees. This demonstration, painted on a 205 x 255mm (8 x 10in) canvas, is about creating shape and form – so I will leave the selection of colours up to you.

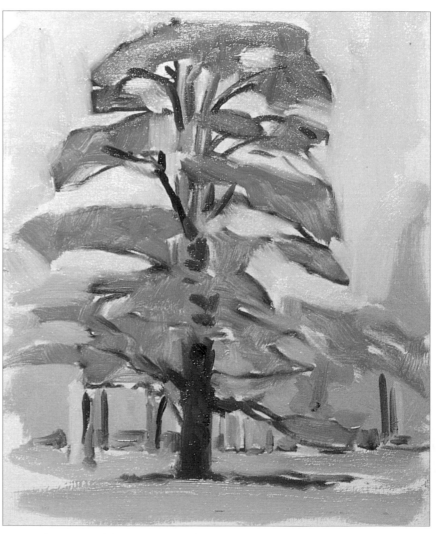

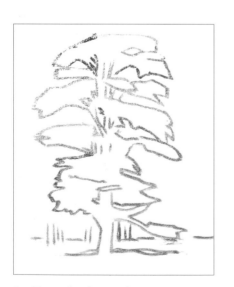

1. Draw in the outlines using a small round sable and a dilute mix of any dark colour.

2. Using thin washes of colour, block in all the areas, adding the dark areas on the trunk and shadows at the base of the tree.

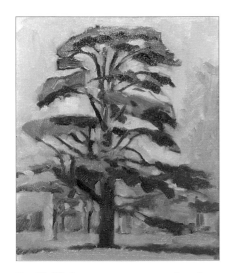

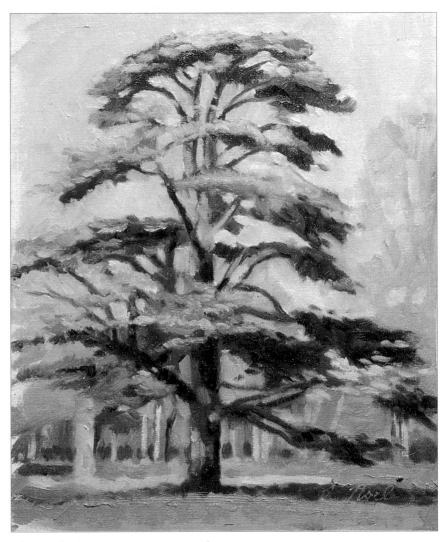

3. Half-close your eyes to 'see' the tree as simple dark and light shapes, then use different mixes of green to create depth in the foliage, and to build up shadows and highlights.

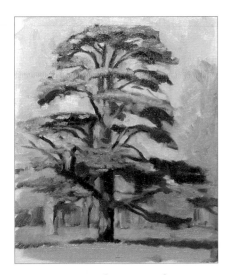

4. Remove and correct shapes in the foliage by creating 'sky windows', i.e. paint over any part of the foliage that looks wrong or needs refining. Keep adding dark and light areas.

### The finished painting

*Details have been added with a small sable brush. Do not overwork the paint – you want to retain a fresh, lively feel.*

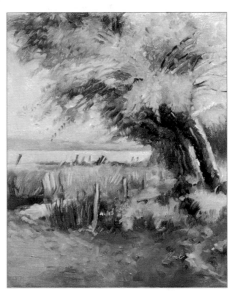

### Willow Tree
*205 x 255mm (8 x 10in)*

*There is very little difference between painting this willow and the cedar tree. Forget about detail – just concern yourself about how shapes appear against the background. When the main areas of tone have been painted, start to work up the details. Finally use a small sable brush to paint in a few individual leaves.*

# Painting water

Water has many moods. The still waters of a pond or lake are a perfect mirror for reflections, whereas a fast-flowing mountain stream and ocean waves can be dramatic and wild. If you are painting still water, reflections are important. They take their colour from the sky and from their surroundings. Whatever appears above the water level will be seen as a reflection. Often, if there is fast-flowing movement in the water or waves, it can be beneficial to take a photograph as a still reference for the effect you want.

> **Note** *Reflections are usually slightly lighter in tone than the subject; this is caused by the light reflecting off the water. You will create a realistic effect if you add a small touch of white to the colours used for the reflected images.*

## Quiet River

This scene has wonderful mirror-like reflections. In simple terms, the top half is a tree landscape, and the same landscape is reflected upside down in the bottom half. I painted it on a 610 x 460mm (24 x 18in) canvas using small- and medium-sized short, flat hog-hair brights, a small round sable, and my palette of colours (see page 8).

1. Use a mix of burnt sienna, French ultramarine and a touch of white to block in all the dark areas. Paint in the top shapes first, then add their reflections. Remember to use slightly lighter shades of colour for the reflections.

2. Block in the sky using a mix of French ultramarine and titanium white, then paint in the reflection. Add warmer colours to the top right of the sky, then repeat the colours in the reflection below.

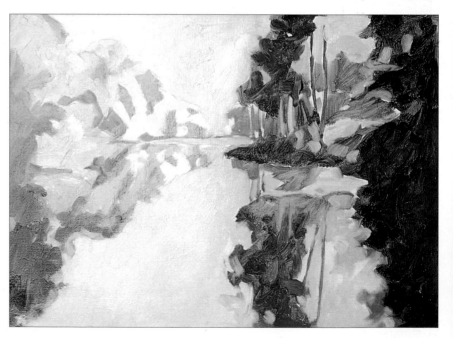

3. Continue blocking in colour until the whole canvas is covered. When you block in a tree, follow up by working on its reflection. If you paint in this way you will create a realistic watery effect.

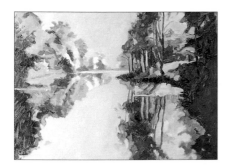  

4. Continue working colour into the blocked-in areas. Build up the shape of the trees, foliage and reflected images, strengthening and readjusting the tone as you work each area.

5. Use a clean dry brush to soften areas, blending and moving the paint around while it is still wet without adding more colour. Work one area and then its reflection before moving on.

6. Work on the foreground reflections, adding more lights and darks. Blur these more detailed reflections, by blending the paint with a clean brush, to create the effect of any slight movement in the water.

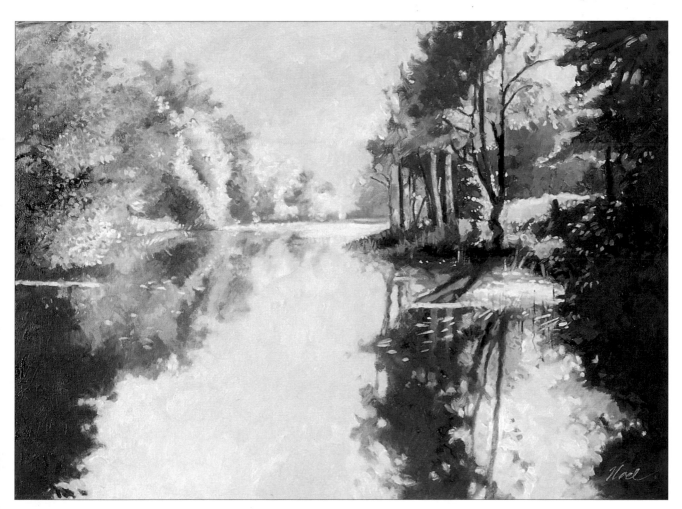

*The finished painting*

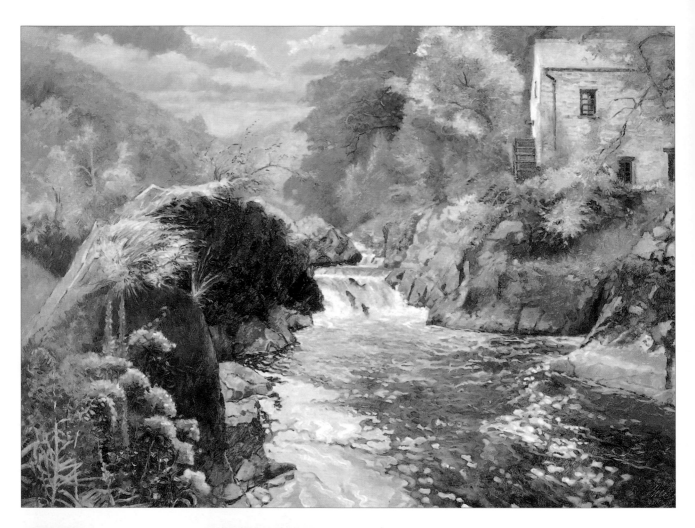

### Cenarth Falls
*1015 x 760mm (40 x 30in)*

*This picture was painted* in situ *at Cenarth falls in South West Wales, not far from my home. It took nearly a week to complete and the only part of the painting to cause a problem was the fast-moving stretch of water. After several attempts at capturing the ever-changing shapes and colours, I decided to take a few photographs and finish the painting in my studio. This turned out to be a wise decision because after a week of incessant rain, the spot where I had been standing was under 1m (3ft) of water.*

*Painting large canvasses in this way has one distinct disadvantage – you and the canvas are subjected to the 'elements' for long periods of time. In the past I have suffered from numerous 'rain stops play' periods, and I have had to rescue more than one canvas from the river! However, unlike watercolours or pastels, oil paints are relatively water-resistant and you can often carry on painting, despite the weather.*

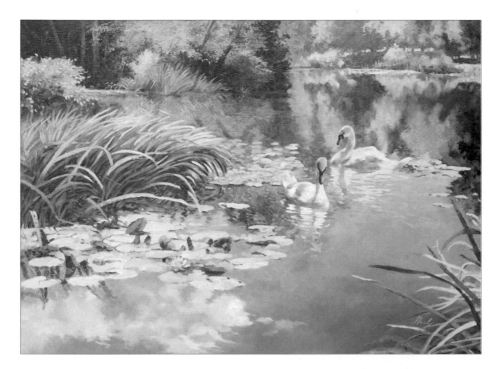

### Swan Lake
*1015 x 760mm (40 x 30in)*

*Water is one of my favourite subjects and here I wanted to capture the beauty of the perfectly smooth surface on this lake. Water takes on the colour of its surroundings and because of the high horizon line it is the reflected sky, not the sky itself, that makes this composition. Do not be afraid to use sky reflections in calm water like this, for it produces a great feeling of depth. It is not as difficult as it first appears – it is just like painting a sky upside down!*

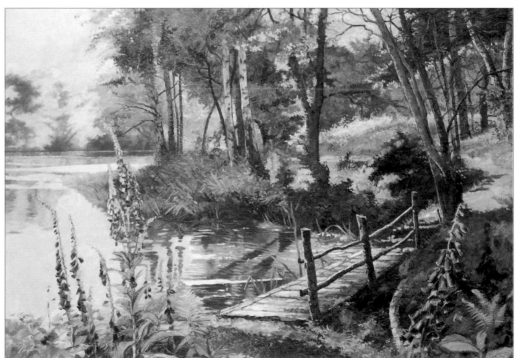

### Foxglove Bridge
*1015 x 760mm (40 x 30in)*

*This landscape is more advanced in structure than the other paintings on these pages, and it took nearly two weeks to complete. The pond is a beautiful example of Georgian man-made landscaping. The bridge is in fact hundreds of miles away from the pond, and I used an old watercolour sketch (painted many years ago) to complete the painting. I added the bridge because I felt it greatly enhanced the composition. The foreground flowers were painted from life in the studio.*

# Using photographs

A century ago, artists had no choice but to record images in a sketchbook. Nowadays, you do not have to worry about rain, or having to wait until the sun is in the right place because you can simply take a few photographs at the right time, then recreate the scene at home. Do not be afraid of photographs. I know of few professional artists who have not used them at some time in their life, and I rarely go anywhere without a camera. Whenever you see something of interest, take a few photographs and keep them in a scrap book for future reference.

## Foxglove Lane

This painting is composed entirely from photographs. The actual scene had lots of interesting areas, but the width of the road set them apart. I cut out the best parts from each photograph, then re-assembled them to create a more interesting composition – here, for example, I turned the wide road into a narrow winding lane.

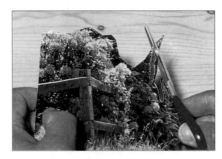

1. Cut the photographs to leave just the most interesting images and features.

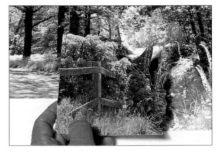

2. Arrange the pieces together, overlapping them as necessary, until you like the composition.

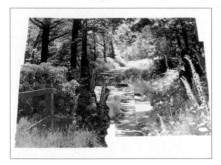

3. Glue the pieces down on to a sheet of paper. Then, if necessary, enlarge the completed scene on a colour photocopier.

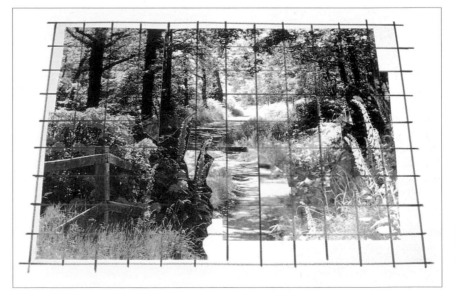

4. Sometimes, I find it useful to draw a grid on the photograph or photocopy. I then draw a similar, but larger, grid on the canvas and transfer the different elements on to the surface.

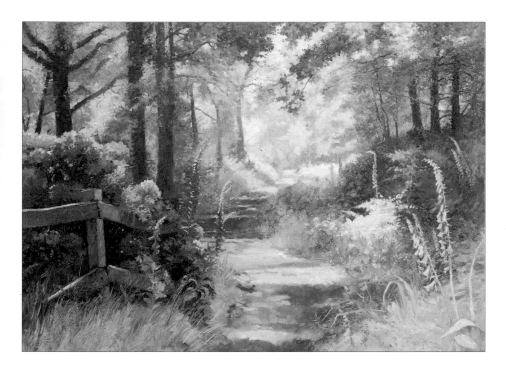

### The finished painting
*1015 x 760mm (40 x 30in)*

*The original road has been transformed into a winding lane simply by moving the rhododendron and fence to the right. When rearranging scenes in this way, you must watch out for uniformity of scale, tone and shadow. You must also be aware of the seasonal changes. For example, you need to know that rhododendrons and foxgloves flower at the same time of year.*

### Rhododendron Garden
*915 x 760mm (36 x 30in)*

*This canvas was composed entirely from reference sources. The background, with the sunlight gleaming through the arch in the hedge, was taken from a greetings card, the plants on the right-hand side were taken from photographs. I cut up the individual pictures and rearranged them into a pleasing composition.*

*For this painting, I wanted a large rhododendron bloom in the foreground, so I cut a couple of stems and painted them from life. I lit them with a spotlight to give the appearance of sunlight. Remember to arrange the position of the light source to correspond to that of the background images.*

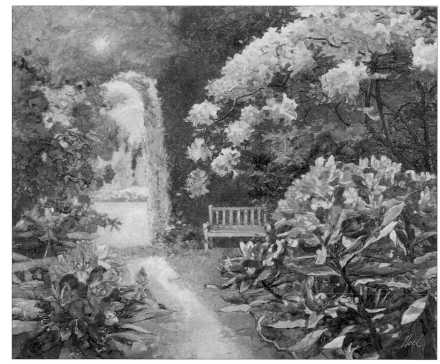

37

# Painting flowers

You only have to look at a still life painted by a seventeenth-century Dutch Master to see what an influence flowers have had on artists. Throughout history their beautiful colours and shapes have inspired painters, and it is just the same today. You should choose flowers that excite you. At first, to make things a little easier, you could perhaps limit the variety of shapes and colours.

## Anemones

The anemone is a good flower to start with because of its intense colours and simple shapes. I chose to paint this arrangement in a plain vase and elected to light the composition heavily from one side to give a good contrast of light and shade.

I used small- and medium-sized short, flat hog-hair brights, a small round sable, colours selected from my full palette (see page 8) and a 305 x 255mm (12 x 10in) canvas. I painted blocks of colour straight on the canvas, but you may prefer to start in the usual way by sketching the outlines. Do not spend too much time on individual flowers, only to find they are in the wrong place. Look at the whole shape and the individual units will be correct.

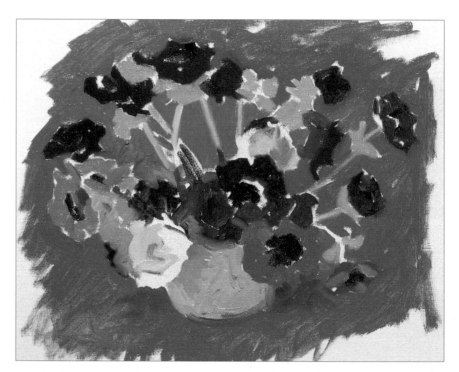

1. Block in the whole canvas with simple shapes that create the basic impression of the flowers.

2. Build up areas of tone to start creating a three-dimensional effect. Paint over any parts that need refining. Keep adding dark and light areas.

3.  Continue adding more colour. Gradually work smaller areas to create darker shadows and brighter highlights.

4.  Use a small round sable brush to paint in the fine detail. Add bright highlights and strengthen the really dark areas.

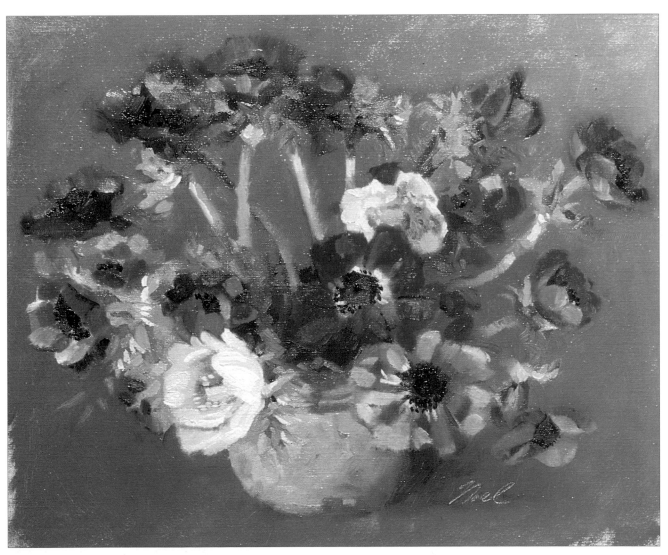

*The finished painting*

### Anemones on a Garden Chair
*510 x 405mm (20 x 16in)*

*This painting was heavily lit from one side. This is a trick I use frequently as it produces a realistic effect of sunlight.*

### Monet's Garden, House and Studio
*610 x 710mm (24 x 28in)*

*If I had to choose a favourite flower to paint it would be the iris. This flower was also one of Monet's favourites, so I am in good company.*

*This painting was created in my studio from a photograph. I took the liberty of including more irises in the foreground, which adds interest and gives a feeling of depth when they are viewed against the distant hills.*

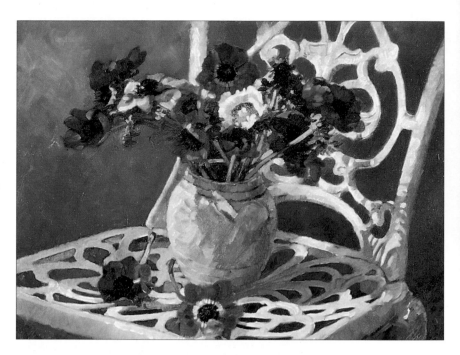

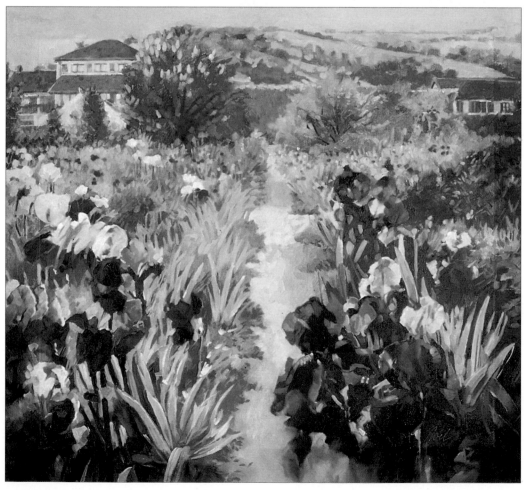

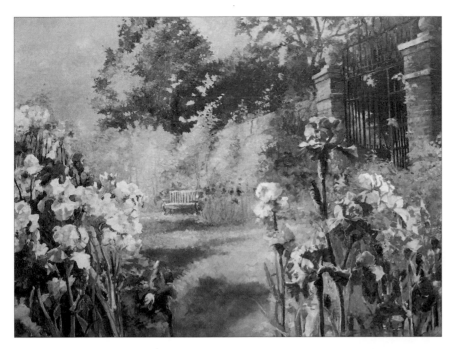

### Iris Garden
*1015 x 1270mm (40 x 50in)*

This large painting is really just one stage on from a still-life flower study. It was created from photographs of plants from a seed catalogue, a gate from a photograph in a gardening magazine, a garden bench from memory, and a still-life composition in the studio.

There is nothing wrong with putting all these 'ingredients' into a composition. As long as the colour structure remains unified, the picture should work well.

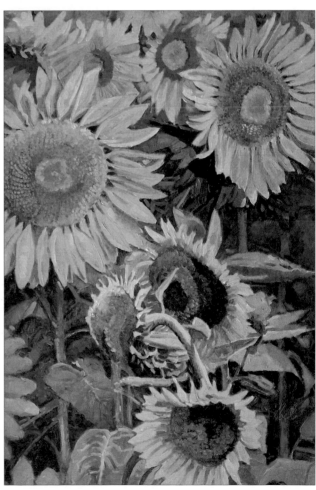

### Sunflowers
*510 x 760mm (20 x 30in)*
These sunflowers were developed in the same way as the demonstration of anemones on page 38. They were arranged in a large container and lit with a light source from one direction.

# Painting animals

Animals could be the subject of a whole book, but here I only have room to show you my personal favourites. Animals never keep still long enough to paint from life, so I invariably use photographs as reference.

There is a long tradition of painting animals and you only have to see the prehistoric cave paintings in Tassili, Southern France, to realise just how long artists have been fascinated with this subject. In more recent times proud landowner farmers commissioned grossly-distorted portraits of prize-worthy pigs, cows and horses.

The Victorian artists Sir Edwin Landseer and Sydney Cooper realised that animals gave their paintings scale and a focal point. They also knew that the drawn information should be visually correct, otherwise the eye of the viewer would constantly refer to any mistake.

Nowadays, wildlife conservation is of major importance. Never before has there been so much information available about animals and their habitats. Today's art reflects this interest. Photo-realistic artists show exceptional skill in painting these images, and have shown the way to developing this fascinating subject.

## Kitten

Cats and kittens are great subjects to paint. When drawing any animal, try to forget the detail and concentrate on their basic shape and form. For example, the area between an animal's legs is just as important as the legs themselves. You should also look at the angle of the eyes relative to those of the ears and nose. When creating your initial sketch, reduce the shapes to a simple set of straight lines and sketch these on to the canvas.

This picture is painted on a 205 x 255mm (8 x 10in) canvas, using small- and medium-sized short, flat hog-hair brights, a small round sable, and colours selected from my full palette (see page 8).

1. Use a small round sable to draw straight lines to indicate the basic angles of the major features, then roughly sketch in the outlines.

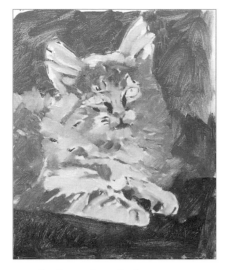

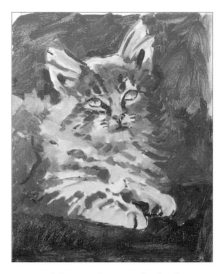

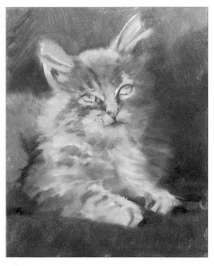

2. Block in the whole canvas, using linseed oil to dilute the colours.

3. Build up colour with thicker paint. Add more shape to the fur and start to work on tonal values.

4. Move the paint around with a dry brush to soften the fur. This will be easier to do if you let the paint dry slightly.

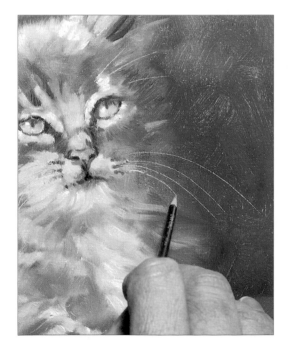

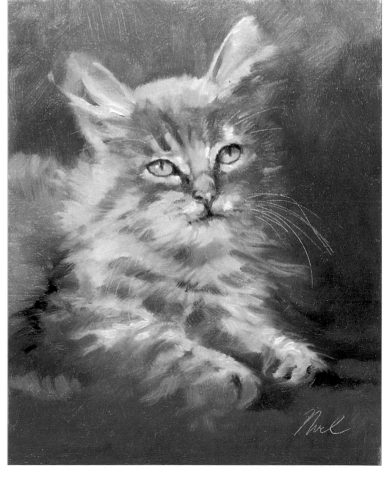

5. Start adding detail. Carefully paint in the features, the longer hairs and the darker shadows. Finally, using quick downward motions with the sharpened handle of a small brush, draw in the whiskers.

*The finished picture*

# Ducklings

I love painting ducks and ducklings as they are most amusing. Here are two ducklings which, apart from their obviously different shape, can be painted in the same way as the kitten on page 42. Break them down into simple shapes, block in the colours and then gradually start adding detail. Duck down is very similar in texture to cat fur, so remember to let the underpainting dry slightly before using a dry brush to soften it.

I have used small- and medium-sized short, flat hog-hair brights, a small round sable, a 205 x 255mm (8 x 10in) canvas and colours selected from my full palette (see page 8).

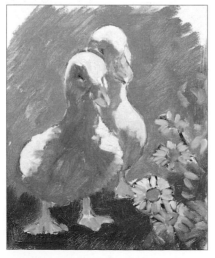

1. Sketch in lines to show the main angles, then roughly fill in the outlines.

2. Block in the main colours, covering the whole canvas.

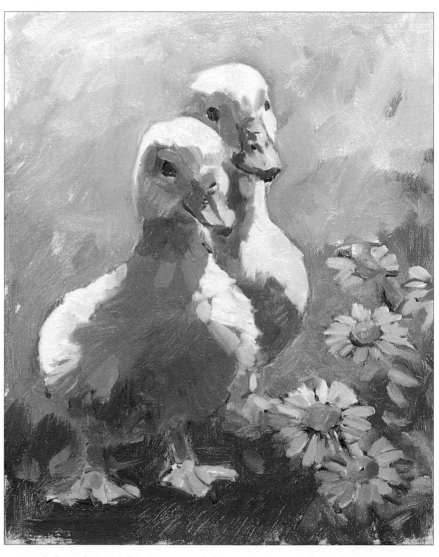

3. Redefine the tonal structure of the composition by adding more paint, and by building up the lights and darks. This is an important stage – here you must start to turn the basic shapes of the ducklings and the flowers into three-dimensional forms.

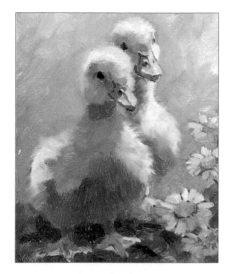

4. Use a clean dry brush to blend the colours together and soften edges. Cleaning the brush regularly with a dry cloth will help retain freshness in the painting, and will stop the colours becoming muddy.

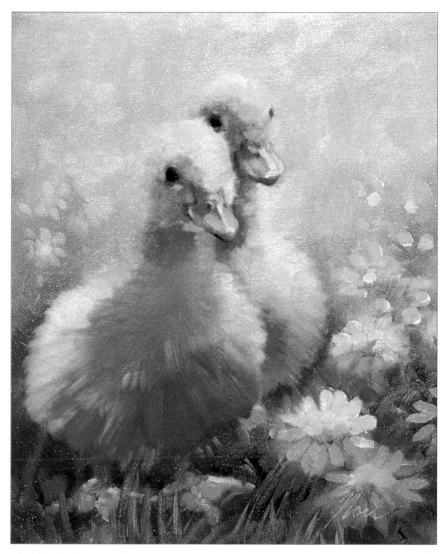

*The finished painting*
*A small sable brush has been used to add more detail to the beaks and eyes. A neat way to sign your finished work is to cut into the wet painting with the sharpened end of a small brush.*

### The Goldfish Bowl
*510 x 405mm (20 x 16in)*

*The composition for this painting of my own cats – Marilyn, Amberlyn and their mother, Velosa – was created from three separate photographs. The photographs were taken at different times. Notice that although there are five different cats featured in the photographs, only three are depicted in the final painting.*

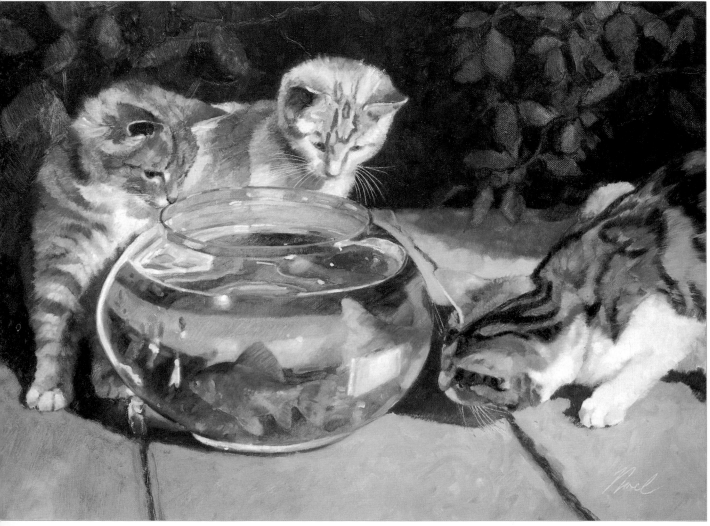

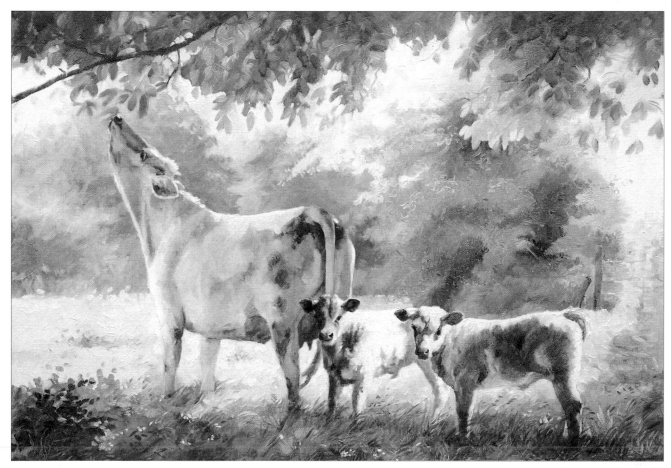

## Mother Cow
*510 x 305mm (20 x 12in)*

*It is very rewarding to paint cows, but few stay still for any length of time – they either trot over and dribble on your canvas, or stay on the other side of the field! Three cows in a row would have produced little interest. However, this painting of a cow and her two calves works because of its simple composition and the tonal contrast of light and shade.*

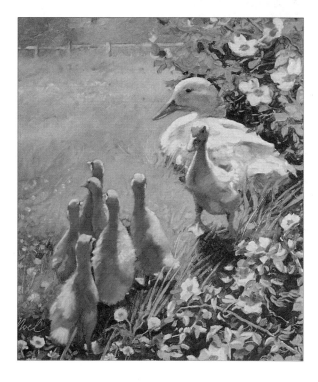

### Mother Duck and Wild Roses
*405 x 510mm (16 x 20in)*

*This painting is a development of the demonstration on pages 44–45. Its simple elements of shape and tone are brought together to form a strong composition. The duck and ducklings are composed from a series of photographs taken when the young were only a few days old. The wild roses were arranged as a still life in the studio.*

# Index

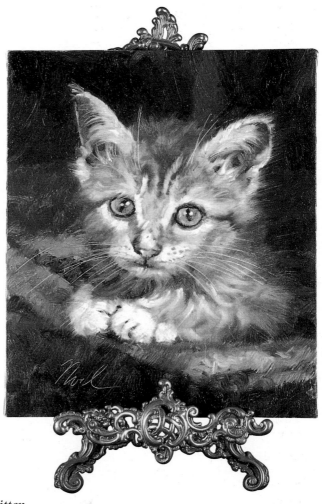

*Kitten*
*255 x 305mm (10 x 12in)*

*This appealing picture was created using a series of simple shapes and angles, similar to those for the demonstration on page 42.*